The Craft of
Quilling

Janet Wilson

Search Press

First published in Great Britain 1996
Search Press Limited
Wellwood, North Farm Road,
Tunbridge Wells, Kent TN2 3DR

ISBN 0 85532 797 9

*To Lyn Bell, who tried the patterns out. To Brenda
Rhodes, who inspired me to take up quilling seriously
all those years ago. To Dolly, my mother, who fed
and watered me.*

Suppliers
If you have difficulty in obtaining any of the materials and
equipment mentioned in this book, then please write for a
current list of stockists, including firms who operate a mail-
order service, to the Publishers.
Search Press Limited, Wellwood,
North Farm Road, Tunbridge Wells,
Kent TN2 3DR, England

*Page 1: Hand-made and hand-cut quilling paper was used to
reproduce this pattern which I found in an eighteenth-
century ladies' magazine.*

Printed in Spain by Elkar S. Coop. Bilbao 48012

Contents

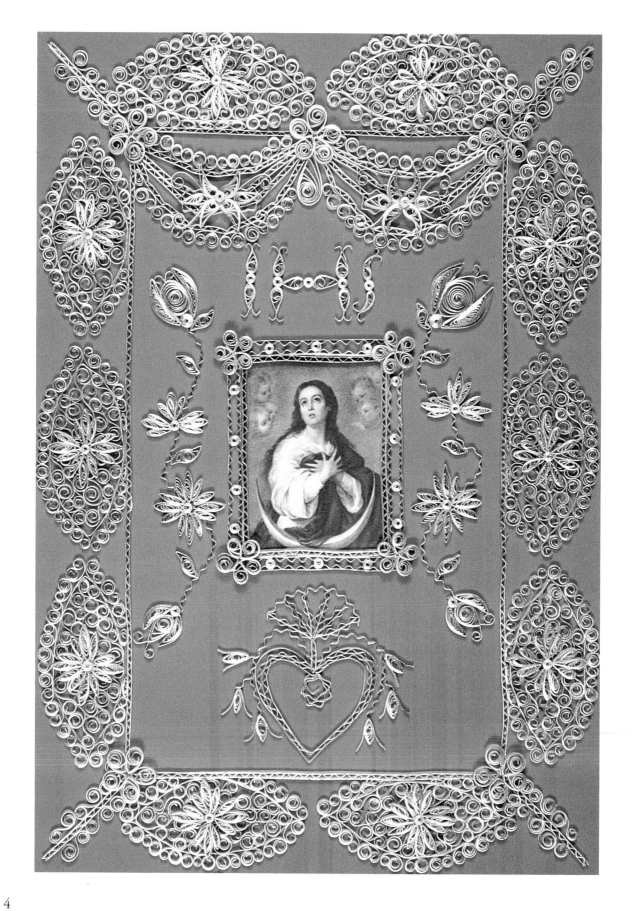

Introduction and history

When and where did the craft of quilling or, as it is also known, paper filigree, start? Most evidence points to the Mediterranean area, in around the fifteenth century, where the poorer religious houses used gilded paper, probably stripped from the edges of their bibles and missals, to decorate their reliquaries and holy pictures. The paper was probably wound around goose quills, which were used in that era as pens – hence the word quilling – to produce rolls, which were then pinched into various shapes. The resulting shapes, when glued together, are reminiscent of gold filigree jewellery. They were used to make wide borders round the reliquaries and pictures. Beads, feathers, threads of gold or pieces of mica were also added to the quilling to give a richness to the finished picture.

In the seventeenth century, quilling was used to decorate the walls of people's homes, in place of the more expensive paintings of the era. The craft was

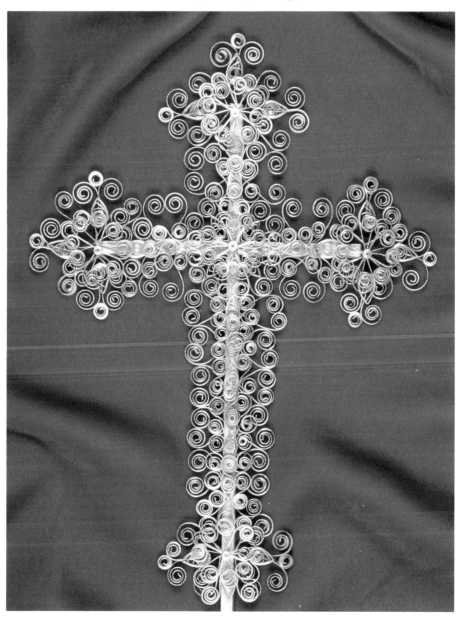

Opposite: One of the original uses of quilling was to decorate reliquaries and holy pictures. For this holy picture I have reproduced quilling styles used in the late seventeenth and early eighteenth centuries.

Right: This is a free-standing gilded paper cross which could be used for a small altar in a house or in a Lady chapel.

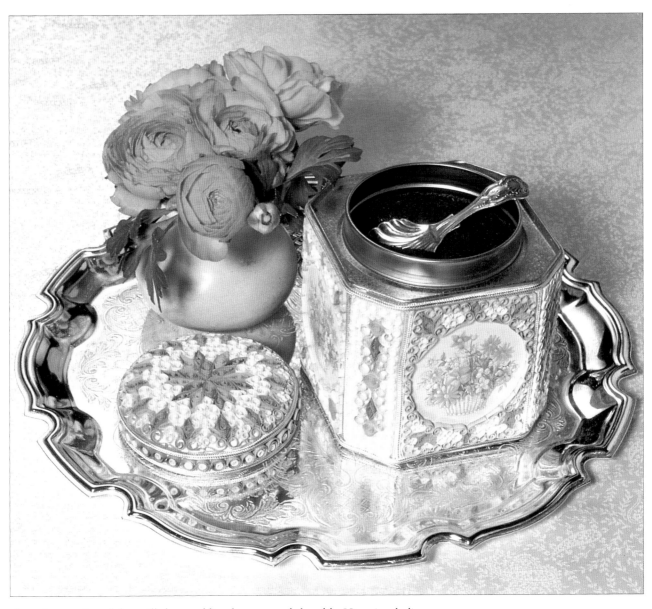

A modern version of the quilled tea caddies that were so beloved by Victorian ladies.

used to reproduce family coats of arms: helms (heraldic helmets) and mantling (the leaf work falling from the helm down the side of the shield) were made out of hundreds of tiny cylindrical or filigree-shaped pieces of paper enclosed by one or two strips of paper to give the sharp edge to these shapes. Pegs of paper were used to raise the mantling from the background to give a three-dimensional effect to areas of the coat of arms. Imitating the original religious use, the coats of arms were often surrounded by borders of further quilling, to which shells, beads and the like were added. The

backgrounds to these wonderful pieces of work were either silk or paper covered with thousands of tiny rolled coils of paper. To add colour to these works of art, the papers were often coloured by hand before being cut and rolled.

The craft was taken by the Pilgrim Fathers to the New World and in America there are examples of candle sconces decorated with quilling, as well as boxes, pictures, and suchlike.

Regency ladies used quilling to decorate their fire screens. These were often shield-shaped and were on

long poles so that they could be adjusted to protect the ladies' faces from the heat of the fire. They also decorated cribbage boards, which could be oval or round instead of just the usual oblong blocks seen today. Vases of flowers were very popular as centrepieces to Regency pictures, and they often had a delicate border around the edges composed of swags and leaves.

Some very famous people have been connected with the craft. Jane Austen's character Lucy in *Sense and Sensibility* is quilling a 'filigree basket' for Annamaria, so it can be assumed that Jane Austen was familiar with it. The Brontë sisters, too, were quillers, as was George III's daughter Elizabeth. Mary Delaney, renowned for her paper-collage work in the eighteenth century, was also a quiller. The *New Lady's Magazine* in 1786 quoted '...it affords an amusement to the female mind capable of the most pleasing and extensive variety; and at the same time, it conduces to fill up a leisure hour with an innocent recreation.'

In Victorian times, tea caddies and various pieces of furniture were specially made with recessed panels by cabinet-makers to allow ladies to use them for quilled work. Examples of this work can be seen at such museums as the Lady Lever Museum in Port Sunlight and the Victoria and Albert Museum in London.

The latest revival of this craft was in the 1970s, when people gradually became more aware of what quilling actually was. Pieces of quilling have been discovered hidden in attics and other out-of-the-way places. Tea caddies sometimes turn up at antiques shows, and antique dealers are now finding a market for such lovely items. Remember that the paper used in these old pieces was cut by hand, so it is unlikely that the surfaces are completely smooth; they will be slightly uneven due to the fact that it is impossible to cut exactly the same width each time by hand.

Today, papers for quilling come in a multitude of colours and in a range of different widths – all evenly cut by machine! So all you have to do is roll the paper and enjoy producing your own works of art.

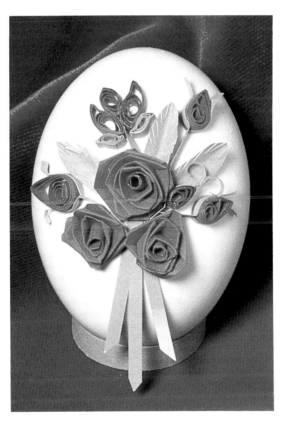

A blown goose egg decorated with quilling. It sits on a stand which is also made from quilling paper.

Materials and equipment

Very little equipment is actually needed to begin this craft. Listed here are the items that you will require.

Quilling paper

Quilling paper comes in a wide variety of colours. I have found that the most popular with beginners are the packs of rainbow-coloured paper, although you can buy packs with 'family' colours of green, red, etc., which include different shades of the family colour plus a few other colours that blend well with them. There are packs available with three different shades of one colour, which are useful if you are going to embark on a large project. There are also specific assortments, such as Christmas colours, which consist of red, green, white and sometimes gold and silver. Once you become really involved in the craft you may feel the need to buy papers with pearlised or gilded edges too.

Paper for quilling also comes in different widths, but for the beginner I recommend starting with the widely used 3mm (⅛in) paper. Children find that 5mm (³⁄₁₆in) or 6mm (¼in) paper is easier to handle when they quill, and this size is also used for making free-standing quilled sculptures or fringed flowers. Paper 7mm (⁹⁄₃₂in) or 10mm (³⁄₈in) wide paper is useful for making fringed flowers or leaves as well as free-standing projects. For those who wish to layer their project, i.e. put one set of petals on top of another to give a more realistic effect, 1.5mm (¹⁄₁₆in) or 2mm (³⁄₃₂in) paper is available.

The most important thing when buying paper is to choose the correct *weight*. If the paper is too thin, i.e. a lightweight paper, then you will find that it will not hold the shape. There is nothing more disappointing for a beginner than to find that what started out as a

Quilling paper is available in a multitude of different colours.

nice sharp mosaic coil has relaxed into a formless shape before it can be stuck on to the background surface, and many people have been put off the craft for this reason. When you roll a filigree or mosaic shape it should *stay* in that shape, so remember, if you have problems then perhaps you are using a paper of the incorrect weight.

In Britain and Europe, paper is sold in 45cm (18in) lengths, while in America it is sold in 60cm (24in) lengths. So, if you are making a design taken from an American book and it refers to using half a strip, remember that this is 30cm (12in) and not 22.5cm (9in). Conversely, American readers using European books (including this one) need to remember that half a strip refers to 22.5cm (9in).

Quilling tools

Quilling tools come in all shapes and sizes – plastic tools, metal tools or even just a needle with the top of the eye snipped off. It is important to choose the right one for you and the right one for the job that you want it to do.

If you are just starting this craft, then make sure that your tool will accept at least 7mm–10mm (⁹⁄₃₂in–³⁄₈in) wide paper. I have spoken to several people who have been so disappointed that they do not seem to be able to roll the shapes that they have given up the craft. The usual problem I find is that the head of the tool is too *short*. It is only just long enough to take 3mm (⅛in) paper and when the unsuspecting quiller rolls the paper it comes up over the end. You can overcome the problem by putting your finger over the end of the tool while you roll, but be careful, as you can give yourself some nasty paper cuts, which are very painful for a while! At first, it is also best to get a tool that has a collar on it, as this makes it easier to roll the paper evenly. As you progress this will become a natural reaction and you will find that you can roll the paper evenly without the aid of the collar.

Most experienced quillers have a number of tools that they use for specific purposes, so do not discard any tool thinking that you have outgrown it. Keep it – you may be glad of it when you roll such things as roses. Often the beginner's tool gives a larger centre to

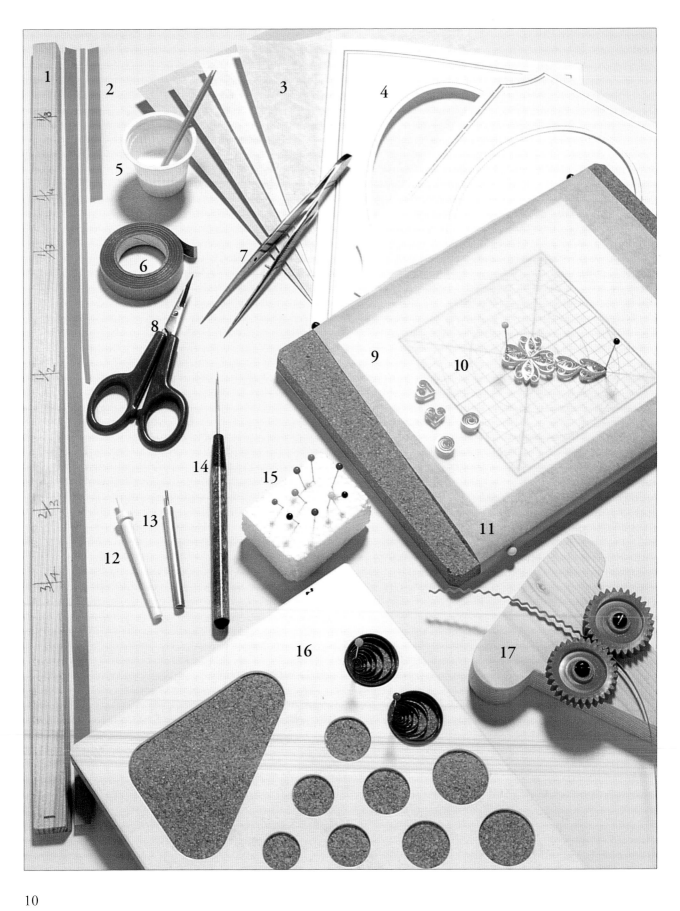

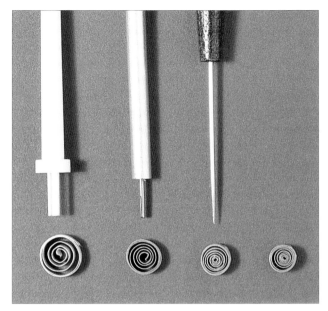

These closed coils show the effects created by using different tools. From the left: plastic beginner's tool with a collar; metal tool, which produces smaller centres; needle tool; and finally, a coil made simply by rolling with the fingers.

the coil, but again, as you become more experienced you can progress to a narrower tool which will give you a smaller centre.

Malinda Johnson, an American quiller, uses a needle to roll her paper. This is reminiscent of Victorian times, when ladies rolled paper around a hat-pin. The needle tool can be difficult to use, although it does seem to be the best one for rolling spirals.

Some people use no tools at all but simply roll the paper in their fingers. There is an art to rolling without a tool, but however much I try I cannot seem to get it

right! Trees Tra, a well-known Dutch quiller and a good friend, spent a long time patiently trying to teach me to roll paper without the use of a tool, but to no avail – I still ended up with a mangled piece of paper. So, if you can roll paper without the use of a tool, wonderful – if not, then be like me and use a quilling tool.

Glue

The best glue to use is PVA or school glue. This is a water-based glue and it dries clear. Put a little glue into a small container – I usually use an empty individual cream carton, such as you get with a cup of coffee at a self-service café. Once you have finished you can then just throw the whole thing away.

Use a wooden cocktail stick to apply glue to the end of the rolled quilling paper – you only need a little bit to glue the coil closed. I usually keep an old teacloth on my knee, which I use to wipe my fingers on from time to time.

If you want to stick your quilling on to a shiny surface, then you will need to use an all-purpose glue, as PVA glue will not create a lasting adherence. Be careful, as some of these glues produce 'strings' which can spoil your work. There are some American glues which look like PVA but are actually all-purpose glues. These work very well and they dry clear.

Key		
1. Quilling ruler	9.	Quilling board
2. Lengths of paper	10.	Grid
3. Backing paper/card	11.	Baking parchment
4. Blank cards	12.	Beginner's tool
5. Glue	13.	Standard tool
6. Double-sided sticky tape	14.	Needle tool
7. Tweezers	15.	Pins
8. Scissors	16.	Designer board
	17.	Crimping tool

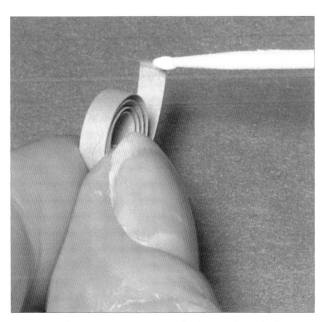

Use a wooden cocktail stick to apply glue to the end of the rolled quilling paper.

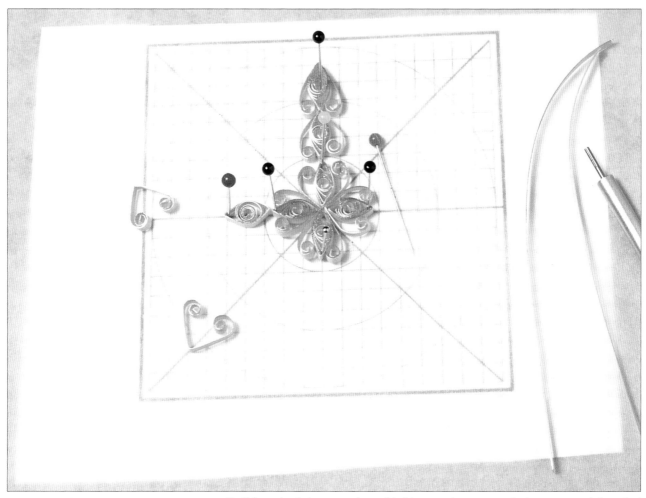

Build up the design on a sheet of baking parchment attached to your work board. A grid is useful for geometric designs.

Quilling boards

A quilling board is a work board on which you can make up your design before attaching it to the surface to be decorated. It is also invaluable for creating free-standing designs, such as Christmas tree decorations.

There are special 'designer boards' on the market. These are made out of cork and on one side have a set of plastic formers which you can use to regulate the size of each coil. These formers are also used for off-centre quilling (see page 19).

You can make your own designer board by sticking rings of different sizes to a backboard. One of my students has a very handy husband who made her a superb designer board out of a sheet of plastic.

A simple board can be made from a square of cork. Cover it with a piece of baking parchment securing it to the cork with drawing pins. If your design is complicated, then you can place a copy of your pattern under the parchment to use as a guide when sticking. The parchment will also prevent any over-zealously glued coils from sticking to the board. Use pins to hold the glued coils in position while the glue is drying. Some students use polystyrene tiles covered with baking parchment on which to make up their designs. In other words, use whatever comes to hand: as long as you can stick pins in the board, you can use it.

Card/background surfaces

Unless your design is to be three-dimensional, you will need some form of background surface on which to place it.

Blank cards can be obtained from several companies who specialize in supplying cards and envelopes – look for advertisements in craft magazines. You can use

aperture cards if you wish: I fix a coloured sheet of paper in the aperture area (using double-sided sticky tape) which will tone with my project.

Small cardboard gift boxes can be bought at some stationers. These are lovely if you want to give someone a small present in a very special box – the box will probably be remembered more than the present!

You can also decorate place cards for special dinner parties – you can buy these from a card specialist or make your own from some thin card. You can make and then decorate your own Christmas crackers and napkin rings; you can also quill on an egg or anything else that takes your fancy. Quilling does not have to be just on cards – use your imagination. Experienced quillers will often see some object or other and say to themselves, 'Can I quill on that?' The answer is usually 'Yes, I can!'

Other equipment

You will need a tiny pair of sharp scissors for cutting the fringed flowers.

A pair of sharp-pointed tweezers is essential for placing small glued pieces on to your design.

You can make yourself a quilling ruler for one-eighth, one-quarter, one-third, one-half, two-thirds, and three-quarters of a strip of quilling paper. This saves time and frustration when it comes to measuring such things as one-third of a strip. Cut a thin piece of wood to the length of a full strip of quilling paper and then mark the other measurements on it.

Using grids

Geometric grids like those shown on the right are invaluable when you want to make sure that components of a design are straight and square to each other, for instance, when making a cross. Make a photocopy of the grids shown here. Place the grid underneath the baking parchment and you cannot fail to get a good result.

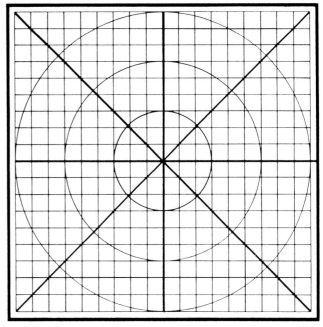

45° grid for use with four- and eight-point star designs.

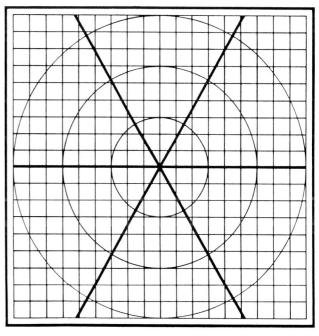

60° grid for use with six-point star designs.

Starting to quill

The best way to learn how to roll your strips of paper is to make a sampler. To do this, firstly make all the shapes, then stick them on to a piece of thin card and write the name of the shape under each piece. A sampler will save you from having to flick backwards and forwards through the book when you are making pieces for a pattern – if you have it in front of you then you will know instantly which shape is required.

I suggest that you use one-quarter-strip lengths of 3mm ($\frac{1}{8}$in) wide paper for your sampler. Measure the lengths against your quilling ruler and then tear them off. If you use scissors to cut the paper, then you will create a sharp end that will show when you glue the coil closed (a ragged, torn end will hardly show at all). Please note that for clarity the shapes on the sampler shown opposite were made using two-thirds-strips of 10mm ($\frac{3}{8}$in) wide paper.

To glue your shape to the sampler, simply turn it over on to a board covered with baking parchment, roll a cocktail stick in glue and smear a little on to the back of the shape. It will not need much glue to stick it down, just enough to hold it to the card.

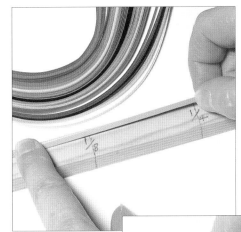

Use a quilling ruler to measure equal lengths of paper.

Tearing the paper to length gives a ragged edge which will become invisible when glued down.

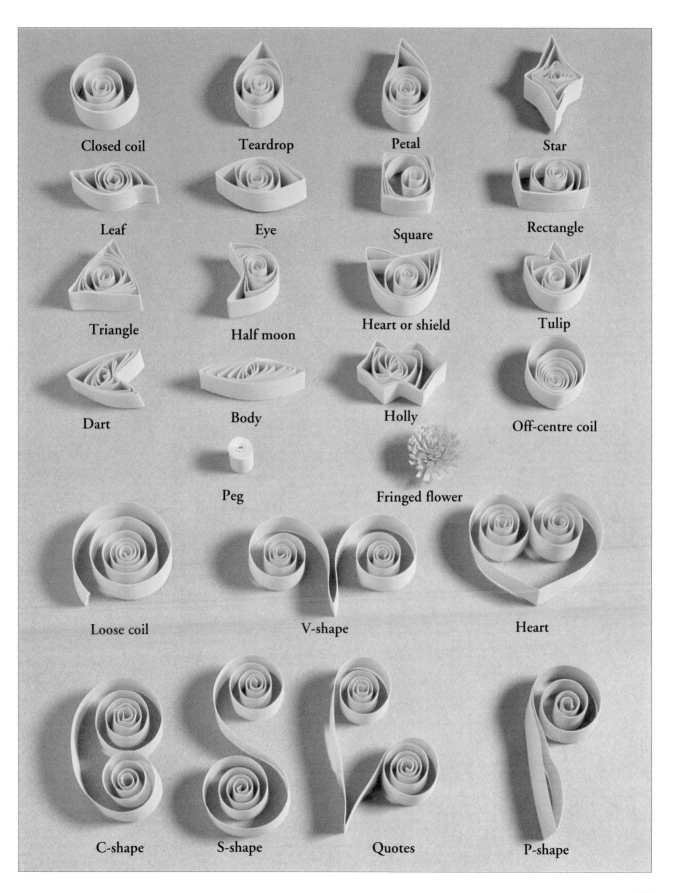

Closed coil

Teardrop

Petal

Star

Leaf

Eye

Square

Rectangle

Triangle

Half moon

Heart or shield

Tulip

Dart

Body

Holly

Off-centre coil

Peg

Fringed flower

Loose coil

V-shape

Heart

C-shape

S-shape

Quotes

P-shape

Rolling a closed coil

Closed coils are used to make most of the mosaic shapes used in quilling designs. The size of the coil will depend upon the length of the quilling paper and the size of the tool used.

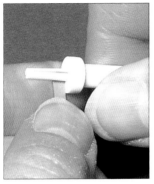

1. Put the end of the quilling paper into the slit in the tool head, making sure that it is resting on the collar of the tool. It should not protrude through the other side of the slit in the head.

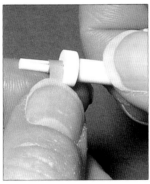

2. Gently roll the tool guiding the paper on to it by letting it run through the thumb and index finger of your other hand. Do not use too much tension or you will screw the head off your quilling tool!

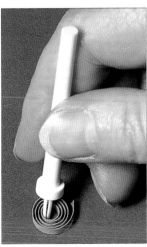

3. When you have finished rolling your piece, turn the tool upside-down and let the coil of paper drop off the tool. You will see it relax just like a watch-spring.

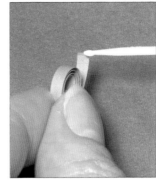

4. Now use a wooden cocktail stick to apply a little glue to the open end. Do not rewind the coil in your hands; you are simply closing it.

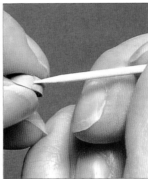

5. Use a clean cocktail stick and gently rub the join to make a smooth finish.

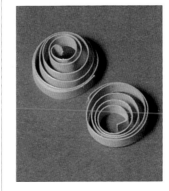

To make a good coil, the paper must be evenly rolled. At first, some of you will be loose quillers, some will be too tight, and some of you will make pyramids, like the one shown here, because you have an uneven tension. However, do not worry, practice makes perfect.

Pinching the mosaic shapes

Make a number of same-sized closed coils and then pinch them as described on the following pages to make a variety of mosaic shapes.

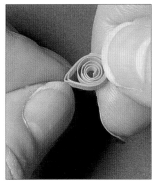

1. Teardrop Hold a closed coil in your right hand and pinch the left-hand side to make a teardrop shape. Use this shape for some flower petals.

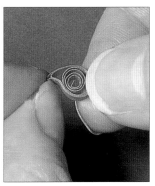

2. Petal This is a variation of the teardrop shape, so pinch the coil as for a teardrop and then turn the pinched end down slightly to curve the top.

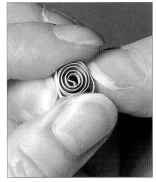

3. Eye Take the coil between the thumb and index finger of both hands and pinch both sides to make an eye shape.

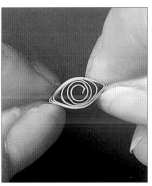

4. Leaf Pinch the coil as for the eye shape and then (still holding the ends) move your left hand upwards and the right hand downwards to complete the shape.

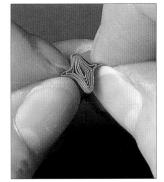

5. Star Pinch the coil as for the eye shape and then (still holding the ends) push the thumbs and fingers towards each other so that they meet. This makes lovely holly with one-quarter- or one-eighth-strip lengths of paper.

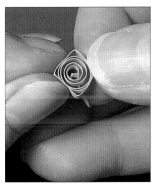

6. Square Hold the coil vertically between your index finger and thumb of one hand, and with your other index finger and thumb, gently close the fingers to form a square shape. . .

. . . When the basic shape has been formed, pinch all four corners to sharpen the shape.

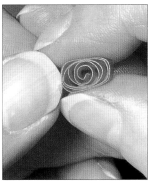

7. Rectangle This is made in a similar way to the square – your right-hand thumb and finger make the longer sides and your other thumb or finger make the short sides. Again, pinch the corners sharp after forming.

17

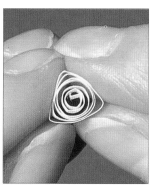

8. **Triangle** Place a coil between the tips of your index fingers and thumbs. Keeping the tips of your fingers together bring up both thumbs to form the shape. Pinch each corner to sharpen up the shape.

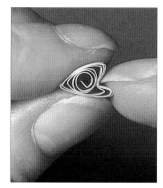

12. **Dart** Pinch as for a teardrop and then, holding the pinched end in the left hand, push the right index finger into the coil until the rounded ends come up over your finger. Pinch the corners to make a sharp arrow-head shape.

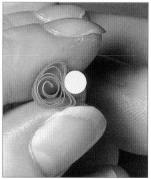

9. **Half moon** Hold the coil in one hand and then, using the handle end of a quilling tool as a former, push the coil against the tool to form the shape. Pinch the two corners.

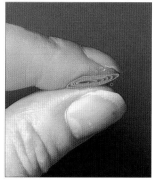

13. **Body** Take a coil and squash it, making a sharp point at each end. This is used for simple butterfly and dragon-fly bodies.

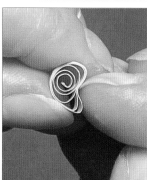

10. **Heart or shield** Hold the coil in the left hand, push the edge of the coil inwards with the index finger of the other hand and pinch the edges round the finger. Carefully squeeze the corners to complete the shape.

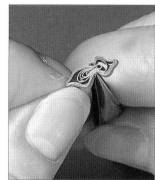

14. **Holly** This shape is best made with paper strips that are over one-quarter of a length. Using a pair of tweezers, pinch the top and bottom of the coil together. Now, pinch one of the sides between your index finger and thumb and push the pinched end towards the tweezers. Still holding the tweezers closed, change hands and repeat at the other end.

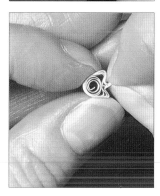

11. **Tulip** Make a teardrop shape and, still holding the pinched end, move it inwards to form the shape.

Rolling off-centre coils

Off-centre coils are made on a designer board (see page 12). They are used to make mosaic shapes slightly different in appearance to those made from simple closed coils.

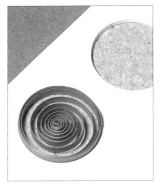

1. Roll your coil and glue it closed. Place it into the right size former on the designer board. If you are using gilded or pearl-edged paper you must place the coil into the former with the gilded or pearlised edge down.

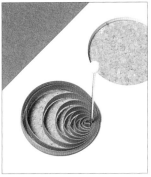

2. Then, using a pearl-headed pin, pull the centre of the coil towards the edge of the former and push the pin into the board.

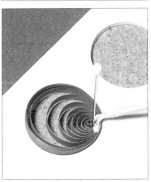

3. Using a cocktail stick, rub glue into the area between the pin and the edge of the former, and leave it to dry. Remember that the side you have glued is the *back* of the coil.

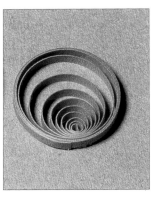

4. When the glue is dry, gently twist the pin, and remove it and the off-centre coil from the board.

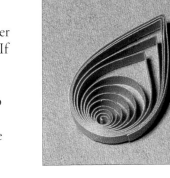

5. You can now use the coil to make any of the mosaic shapes on the sampler. When pinching shapes make sure that the off-centre is at the place in which you want the colour intensified. For instance, in a teardrop the centre will be at the rounded end of the shape.

Rolling a peg

Pegs are tightly rolled lengths of paper that can be used for the centres of flowers and to provide small dense areas of colour.

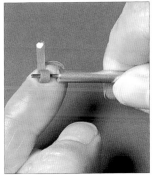

1. Put a little glue on one end of the paper and roll it up on the tool from the non-glued end to form a tightly closed peg. Hold the paper on the tool until the glue dries.

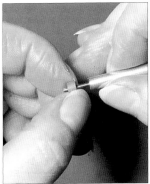

2. Gently ease the peg off the tool using your finger and thumb.

Making fringed flowers

Fringed flowers are made in much the same way as pegs but you use a fringed length of 7mm (9/32in) or 10mm (3/8in) quilling paper.

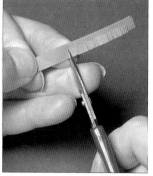

1. Use a one-quarter length of paper and with tiny sharp scissors make a cut three-quarters of the way across its width. Continue cutting in this way along the whole length to make a fringe of paper.

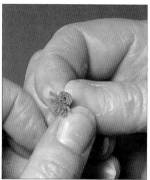

2. Glue and roll the strip as for a peg (see page 19) making sure that the uncut edge is against the collar of the tool. Using your fingers, spread the fringing to produce a pompon-type flower.

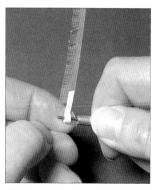

3. To make a flower with a centre, glue a strip of 3mm (1/8in) paper to the end of the fringed piece and roll from the 3mm (1/8in) end.

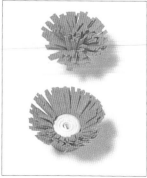

Two completed fringed flowers – one without a centre and one with a centre in a contrasting colour.

Filigree shapes

These shapes look like wrought-iron work. They are rolled without glue. Use one-eighth-strip lengths of paper for your sampler. You can also make many variations of these basic shapes.

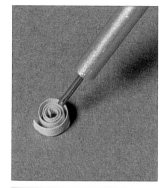

1. **Loose coil** Roll a coil and let it drop off the tool but do not glue the end. This is often used when you are filling in shapes in more advanced quilling.

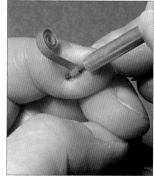

2. **S-shape** Roll one end of a strip to about the mid-point and let it drop off the tool. Turn the strip and roll the other end in the same way. When using gilded-edged paper you may want some reverse-S-shape pieces.

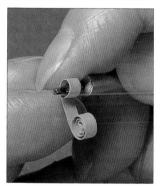

3. **C-shape** This is a variation of the S-shape but you roll both ends of the paper towards the middle.

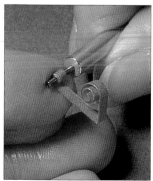

4. **Heart** Fold the strip in half, pinch the fold and then roll each end of the strip inwards towards the fold line.

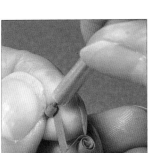

5. V-shape Fold the strip in half, pinch the fold and then roll each end of the paper outwards towards the fold line. This shape makes wonderful antennae for butterflies.

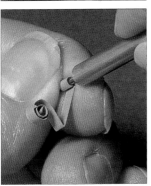

6. Quotes Fold the paper in half, pinch the fold and then roll one end outwards towards the fold and the other inwards (same direction) towards the fold.

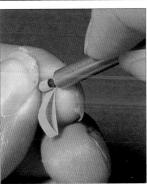

7. P-shape Fold the paper in half and pinch the fold. Place both end pieces into the quilling tool and roll downwards towards the fold. One piece of paper will bow slightly and this is correct.

Making up flowers

Always make up complete flowers on your quilling board before sticking them on to your card. Using this method, you can try different arrangements and then, when you are satisfied, you can glue them down and add leaves and other small pieces.

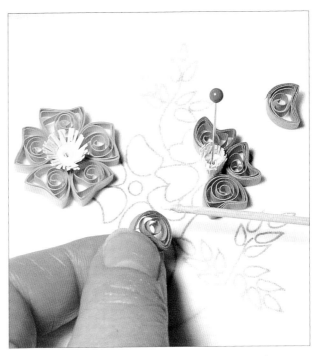

To make up a complete flower, place one shape on your board and put a pin through its centre to stop it from slipping. Take a second shape and spread a little glue along the outside at the point where it will touch the first shape. Place it next to the first shape and lightly press the two together. Again, place a pin through the second shape to hold it in position. Following your pattern, or making up the design as you go along, stick and pin the rest of the shapes until the flower is completed. Once the glue has dried, remove the pins and lift the flower from the board.

Easy first projects

It is a good idea to start by decorating a small flat surface, so in this section I have included a variety of simple greetings card designs for you to try.

Dog roses card

Materials

Blank greetings card
3mm (¹/₈in) quilling paper
5mm (³/₁₆in) quilling paper for fringed flowers

Shapes

You will need to quill the following:

PETALS – ten one-third-strip heart shapes

CENTRES – two fringed flowers made from one-third-strips attached to 3cm (1¹/₄in) lengths of 5mm (³/₁₆in) fringed paper

LEAVES – twenty-four one-eighth-strip teardrops

STEMS AND STALKS – shorts strips glued on their sides

Making up the design

Glue sets of three and five teardrop shapes together on the board to form the leaves. Cut a small slot at one end of a short strip (a stalk) and push each side of the slot outwards to make a 'platform'. Apply glue to the platform, position it across the bottom of the leaf assembly and then smooth each side of the platform into place. You can use this method to attach stalks to individual leaf shapes on other designs.

Make up each flower on the board. Glue the left-hand flower on to the card, then glue the second one so that one of its petals comes up and over the first flower. This gives a three-dimensional effect to your work. Quilling does *not* have to be flat!

Glue the leaf clusters and stems into place on the card. You will notice that the long stem from the left-hand flower has been looped at the bottom and the excess looped paper glued to one side – if you want to do the same on your card you must pinch the loops into the paper before you glue it on to the card.

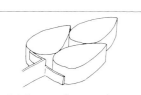

Make two flaps in the end of a stalk and stick this 'platform' around the end of the leaf cluster.

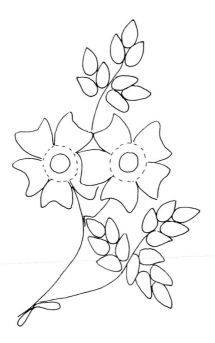

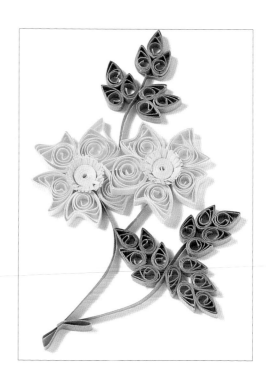

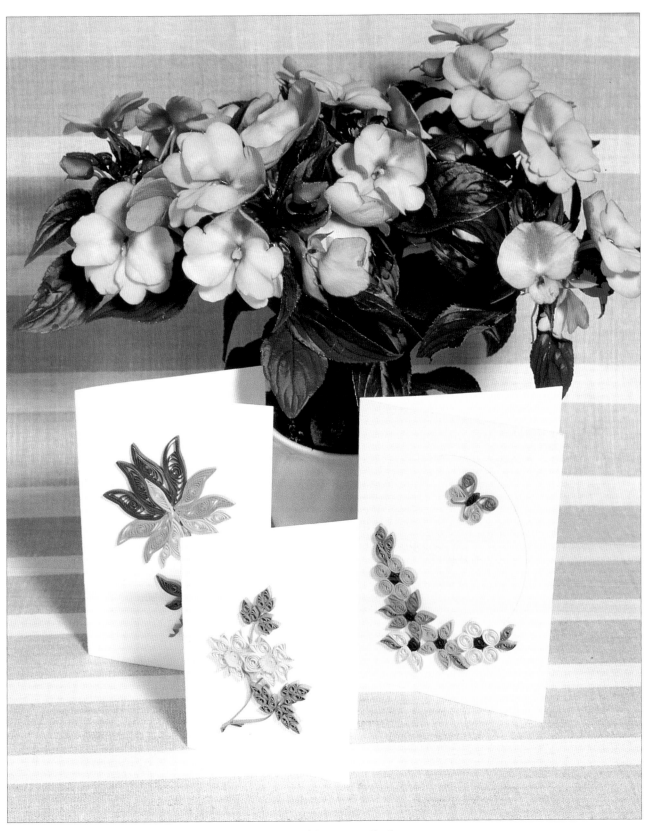

A selection of greetings cards. From the left: Exotic lotus card (see page 25), dog roses card (see opposite) and best wishes card (see page 24).

Best wishes card

Materials
Blank greetings card
3mm ($\frac{1}{8}$in) quilling paper

Shapes
You will need to quill the following:
PETALS – ten one-quarter-strip closed coils
 – thirteen one-quarter-strip teardrops
CENTRES – five one-eighth-strip closed coils
LEAVES – eight one-quarter-strip leaf shapes
BUTTERFLY BODY – one one-eighth-strip body shape
WINGS – four one-quarter-strip teardrops
ANTENNAE – a short strip rolled into a V-shape

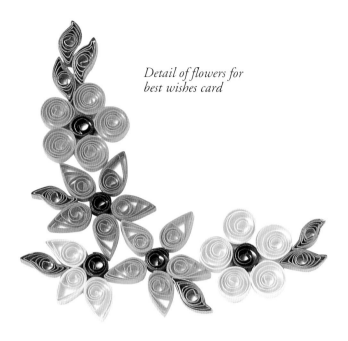

Detail of flowers for best wishes card

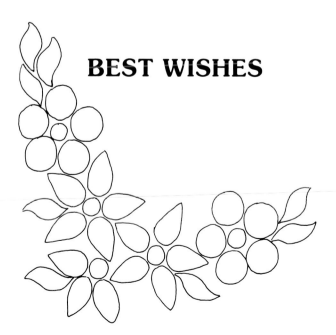

BEST WISHES

Making up the design

THE GREETING I am a great believer in mixing and matching crafts and in this case the greeting has been done using a brass stencil and the technique known as embossing on paper. You can omit the greeting if you like, or perhaps your handwriting is better than mine and you can write it on. The other alternative is to trace the greeting, turn the paper over and scribble on the back and then place it on your card and trace over it again – this way you can see the outline of the greeting and perhaps use a gold pen to write over it. Whichever way you choose, the greeting has to be put on before the quilling.

THE QUILLED DESIGN Make up each flower completely on the quilling board, then the butterfly without its antennae. Arrange these on to your card and then stick them down by rolling the cocktail stick into the glue and then over the back of each piece. Glue down the antennae and glue the leaves into place.

Exotic lotus card

Materials

Blank greetings card

3mm (¹/₈in) quilling paper

A needle at least 3.75cm (1¹/₂in) in length. A well-polished No.14 knitting needle will do, although an American needle tool is better

Shapes

For this card, the petals are made from modified leaf shapes. Use three shades of the same colour to achieve a better effect. You will need to quill the following:

FLOWER CENTRE – one one-half-strip eye shape (pale shade of paper)

PETALS – four full-strip leaf shapes (dark shade)
– four full-strip leaf shapes (medium shade)
– two one-half-strip leaf shapes (pale shade)
– two one-quarter-strip leaf shapes (pale shade)

LEAVES – three one-half-strip leaf shapes
– one one-quarter-strip leaf shape

STEM – a one-quarter-strip spiral

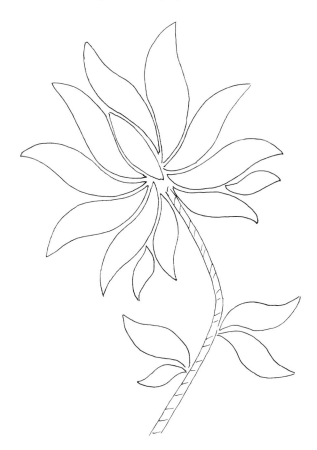

Making up the design

To make a spiral you must use a needle tool. Wrap the end of the paper around the needle and then come slightly off-centre. With the thumb and finger of the right hand guiding the paper, turn the needle with the left hand, thus creating a spiral rope. You will find that at some stage the spiral comes off the top of the needle. Do not worry; this is quite normal, so just carry on.

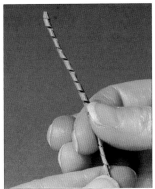

Make up the flower, with its stalk attached at the flower head, on the quilling board. Apply glue to the flower head, and also apply small dots of glue along the spiral. Holding the end of the spiral away from the card, secure the head in place and then bend the spiral to make the desired stalk shape. Hold it in place until dry, then attach the leaves.

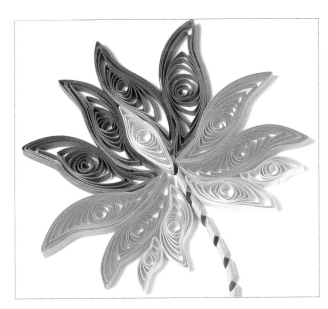

Ever thine card

Materials

Blank greetings card

3mm (¹/₈in) quilling paper. If you have some gilded paper, use it for the outline of the heart. If you do this, you must reverse half of the S-shapes

Shapes

You will need to quill the following:

HEART – thirty one-eighth-strip S-shapes
 – two one-eighth-strip pegs

PETALS – twenty-five one-eighth-strip closed coils

FLOWER CENTRES – five one-eighth-strip pegs

LEAVES – seven one-eighth-strip leaf shapes

Making up the design

THE GREETING To make the greeting on this card I have used the Victorian craft of paper pricking. First of all, trace the shape of the heart and the greeting on to a piece of tracing paper. Scribble over the greeting on the *right* side of the paper. Place the traced pattern over the back of your card front and trace again the back-to-front greeting. You should be left with a clear outline of the lettering. Using a pin, prick along the line of the greeting, working from the back. You will end up with a raised greeting on the front of your card. Now scribble over the heart shape on the *back* of the tracing paper. Place the paper on to your card, lining it up with the greeting already pricked, and go over the shape lightly with a pencil – you will end up with a light outline guide.

THE QUILLED DESIGN When attaching such things as S-shapes to the card I usually put a little glue on to a piece of baking parchment, pick up the shape with tweezers, dab it into the glue (being careful not to pick up too much) and then place it on to the card. Start with two S-shapes to form the top of the heart and then place a peg beneath them to give the top point. Follow round with S-shapes until you come to the bottom, which should again be two S-shapes meeting. Place a peg beneath them to make the bottom point.

Make up the flowers on the board, place them in position on the card and, when you are satisfied with the arrangement, glue them down. Attach the leaves.

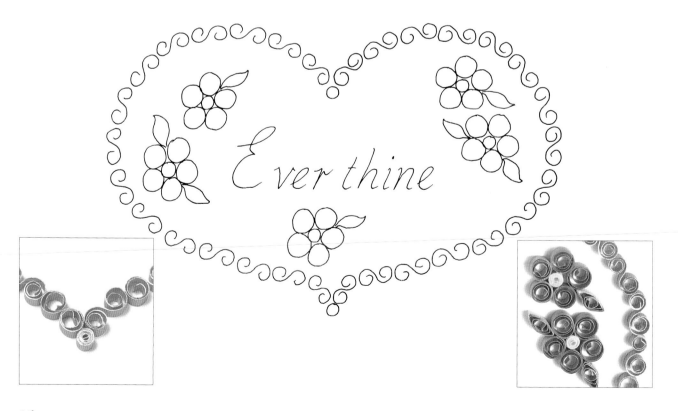

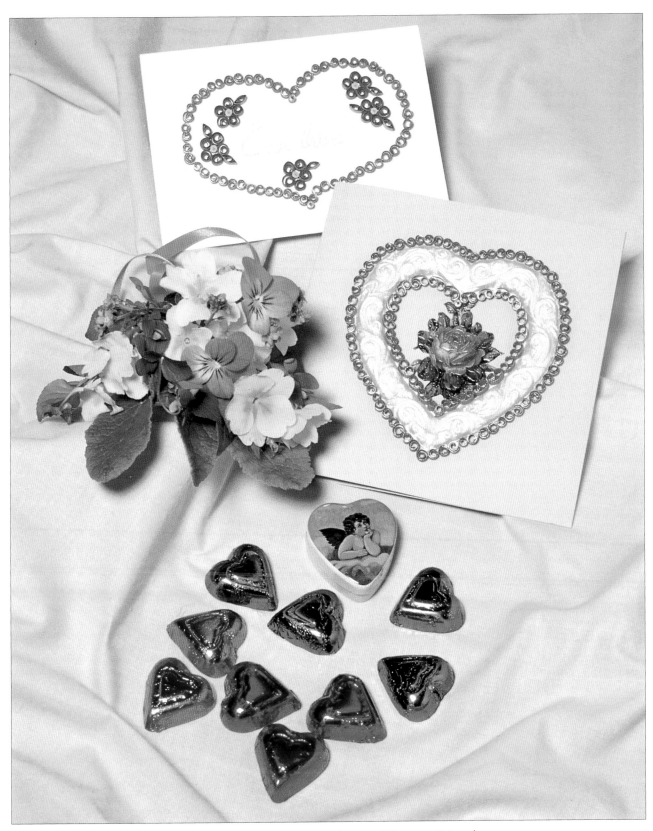

Quilled cards are ideal for those special personal occasions. Ever thine card (see opposite) and Valentine's Day card (see page 28).

Valentine's Day card

Materials

Blank greetings card

Heart-shaped cotton paper casting

3mm (1/8in) quilling paper

White pearlised ink

Victorian scrap (optional)

Shapes

You will need to quill the following:

CENTRE – twenty-four one-eighth-strip C-shapes
– one one-eighth-strip peg

OUTER EDGE – thirty-four one-eighth-strip S-shapes
(half of which should be reversed-S-shapes)

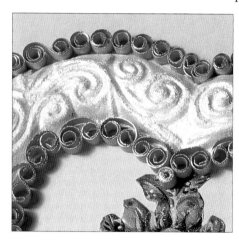

Making up the design

This is another example of mixing and matching crafts. The background heart shape is part of a cotton paper casting, which is made by shredding special cotton pulp in water and then pressing it into a terracotta mould until dry. The resulting casting is lightweight and can easily be glued on. I cut out the central piece of the moulding and also the shaped edging, leaving just the embossed heart shape. I then painted this with white pearlised ink. In the centre I have put a Victorian scrap, but you could just as well cut out a flower from a card or a piece of wrapping paper.

Glue the cotton paper casting to the card with all-purpose or tacky glue (applied to the edges only) and then glue the scrap into position. Now apply the quilling, the C-shapes around the inner edge of the heart and the S-shapes around the outer edge.

Projects for special occasions

There are many occasions which call for a card hand-made with love – the birth of a baby, a christening, weddings, First Communions, wedding anniversaries and bereavements. Here are some ideas for you.

New baby/christening card

Materials

Blank greetings card

1.5mm ($^1/_{16}$in) or 3mm ($^1/_8$in) quilling paper

Three embroidery beads or pearls and all-purpose glue (optional)

Shapes

I have used 1.5mm ($^1/_{16}$in) paper for this design, but you can of course use 3mm ($^1/_8$in) paper. I have also used pearls which I bought from an embroidery shop for the three flower centres, but you could use pegs instead. The top and bottom layers of the flowers use the same shapes but, for greater impact, I have used two shades of the same colour for each flower. You will need to quill the following:

FLOWERS – twenty-four one-sixth-strip eye shapes
– twelve one-sixth-strip teardrop shapes

FLOWER CENTRES – three beads or pearls, or three one-eighth-strip pegs

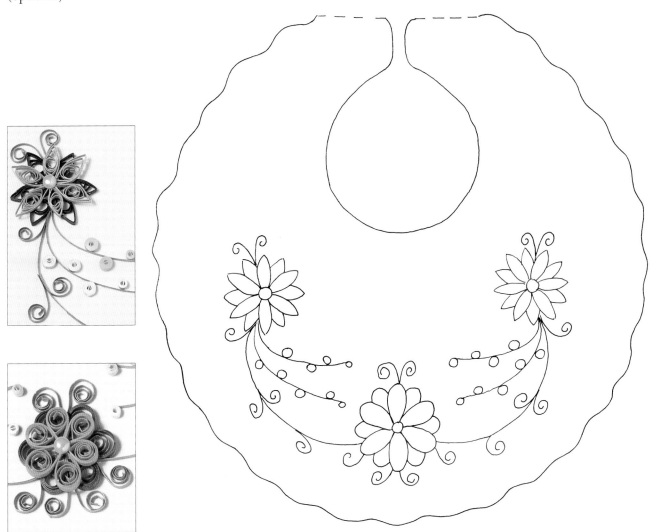

PEG FLOWERS – ten one-eighth-strip pegs
 – eight one-sixteenth-strip pegs
STEMS – strips of paper glued on their sides
TENDRILS – ten one-eighth-strip loose coils
 – four one-eighth-strip V-shapes

Making up the design

THE CARD This card is shaped like a baby's bib and was cut from a larger card. Trace off the bib outline, scribble over the back of the outline, then place the top of the bib on to the fold line of the card and draw around the outer edge and the neck edge. Cut it out.

THE QUILLED DESIGN Make up the flowers on the quilling board and then position each one on the card and glue it down. From strips of paper, make the stems extending from each flower towards the middle (use the pattern as a guide). Glue the V-shapes into place and then glue the loose-coil tendrils into place. Arrange the peg flowers along the top two stems on each side of the central flower and glue into place. Finally, if you are using them, glue the pearls to the centres of the large flowers.

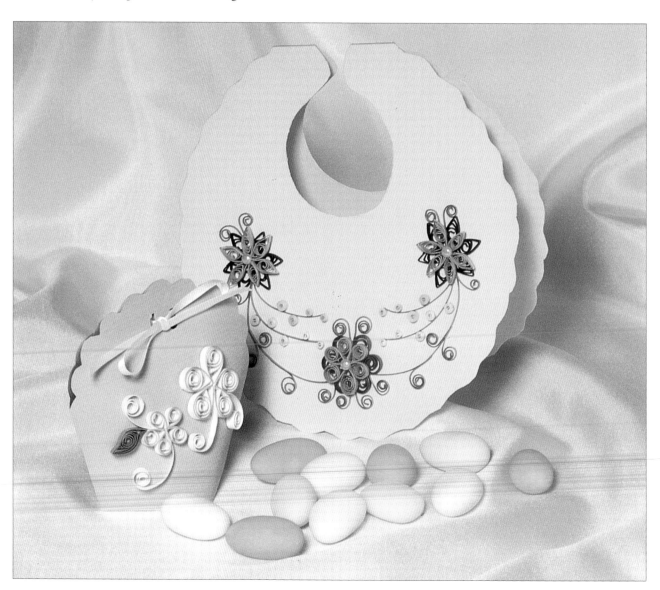

From the left: Christening/wedding bonbonnière (see opposite) new baby/christening card (see page 29).

Christening or wedding – a bonbonnière

The European idea of giving each guest a little package of sugared almonds at such celebrations is fast catching on, so here is a pattern to enable you to make your own for that special day.

Materials

Piece of thick art paper or thin card

Length of 3mm (¹/₈in) wide ribbon

Double-sided sticky tape

3mm (¹/₈in) quilling paper

Shapes

You will need to quill the following:

PETALS – five one-quarter-strip teardrop shapes
 – five one-eighth-strip teardrop shapes

LEAF – one one-quarter-strip leaf shape

TENDRILS – four one-eighth-strip loose coils

Making up the design

Cut out the packet shape from the pattern below (the broken lines denote fold lines). Then, using double-sided tape on flap A, stick the sides together.

On the quilling board, glue each flower together and add the tendrils. Then, glue the flowers into position on the front of the bonbonnière.

Now assemble the bonbonnière. Fold flap B down first; then fold the two identically shaped flaps C down and slot them under flap B; now bring flap D down and slot its tab into flap B. Thread the ribbon through the top holes and tie it closed with a bow.

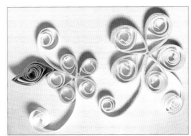

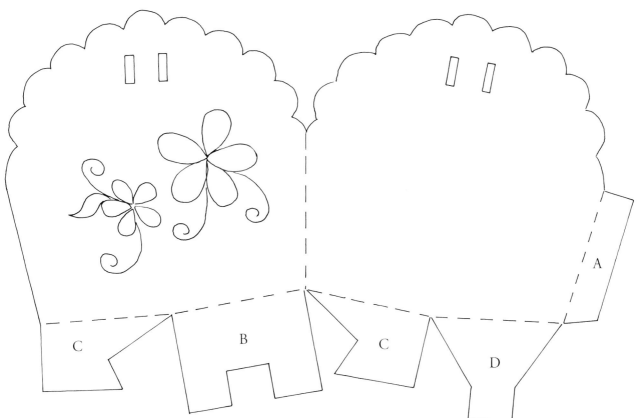

First Communion or condolence card

Materials

Dark-coloured blank greetings card

3mm ($\frac{1}{8}$in) quilling paper

For a First Communion card use a white or silver-edged white paper, but for a condolence card a pale lilac or pearl-edged lilac paper would be more suitable.

Shapes

You will need to quill the following:

CROSS – nine one-quarter-strip eye shapes
 – thirteen one-eighth-strip filigree heart shapes
 – eight one-eighth-strip pegs
 – one one-quarter-strip closed coil

INITIALS – six one-eighth-strip teardrops
 – three one-eighth-strip eye shapes
 – one one-eighth-strip peg

Making up the design

Put a 45° grid under the baking parchment on your quilling board and use the cross lines as a guide when assembling the cross.

Glue four of the eye shapes inside four of the heart shapes at the fold line. Put a dab of glue on either side of each eye shape, about three-quarters of the way up, and attach each side of the heart to these points.

Now, glue these four pieces together to form the centre of the cross, making sure that each eye shape is on the lines of the grid to keep it square. Glue the closed coil above the centre point of the cross.

Next, glue the other five eye shapes to five heart shapes at the fold line. Put a little dab of glue on either side of the other end of the eye shape, bring up each side of the heart and attach them to these points.

Assemble one of these pieces to each arm of the central cross and place the final one below one of these pieces to form the bottom portion of the cross.

Glue the other four heart shapes to the end of each arm of the cross. Glue a peg inside each heart-shaped end and also at the joint of each heart that makes up the centre of the cross.

Finally, transfer the design on to your card. If you want to personalise the card you can make up and glue on the initials of the recipient (in this case I used the initials IHS).

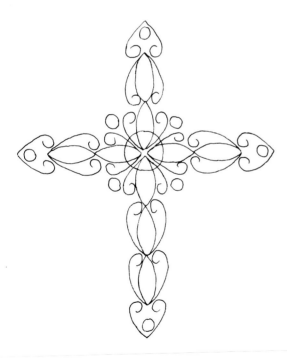

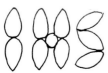

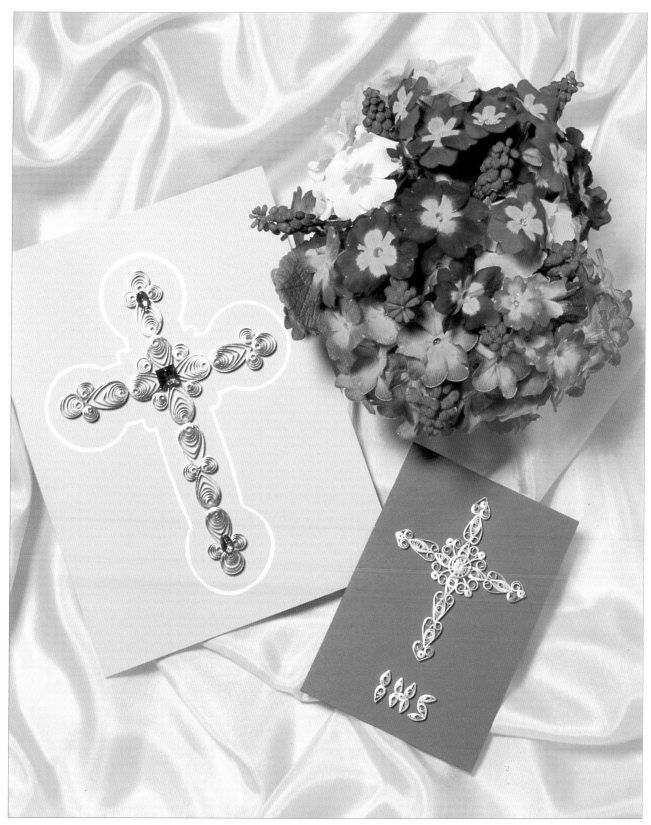

From the left: A cross made from off-centre coils and decorated with embroidery stones, and the First Communion or condolence card (see opposite).

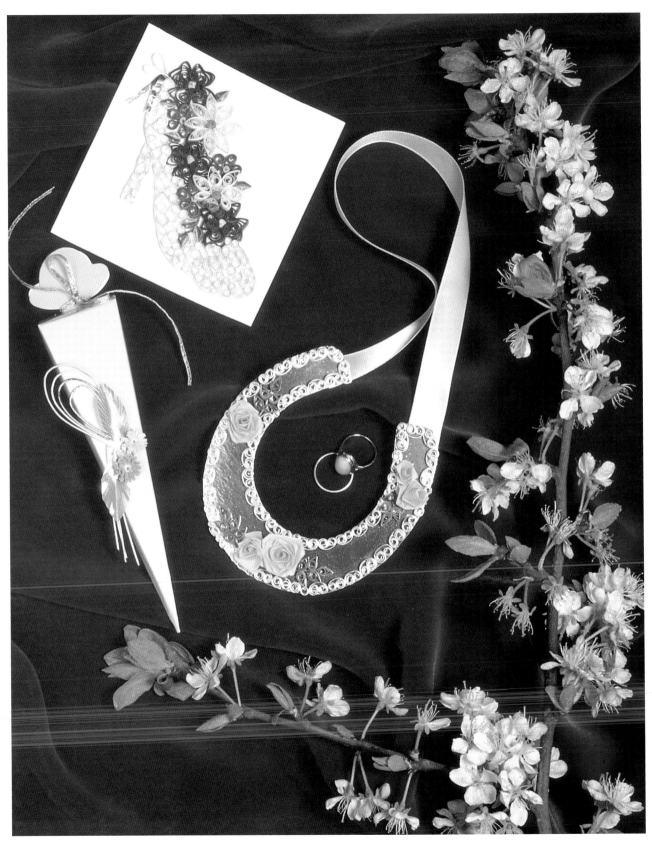

A selection of wedding mementoes.

A wedding horseshoe

Give a bride a special reminder of her wedding day!

Materials

Piece of shiny silver card

Length of white 12mm ($\frac{1}{2}$in) wide ribbon

Two small white sticky labels

3mm ($\frac{1}{8}$in) quilling paper

7 or 10mm ($\frac{9}{32}$in or $\frac{3}{8}$in) quilling paper for the ribbon roses

All-purpose glue

Shapes

You will need to quill the following:

HORSESHOE – approximately fifty-two one-eighth-strip C-shapes (white or silver-edged white)

LEAVES – twenty one-eighth-strip teardrop shapes

STEMS – short strips glued on their sides

RIBBON ROSES – two 29cm (11$\frac{1}{2}$in) strips

– one 15cm (6in) strip

– one 10cm (4in) strip

– one 5cm (2in) strip

See overleaf for details of making ribbon roses.

Making up the design

THE HORSESHOE Using a soft pencil, trace the horseshoe shape on to a piece of paper and place it pencil-side down on to the white back of the silver card. Draw over the pencil line and remove the tracing paper. Carefully cut out the horseshoe.

Place one end of the ribbon behind one side of the horseshoe and fix into place with a sticky label (this covers the raw edges as well). Decide how long you want the ribbon to be, then cut it to size and fix the other end into place.

Remember to write on the back of the horseshoe who it is from *before* you start quilling.

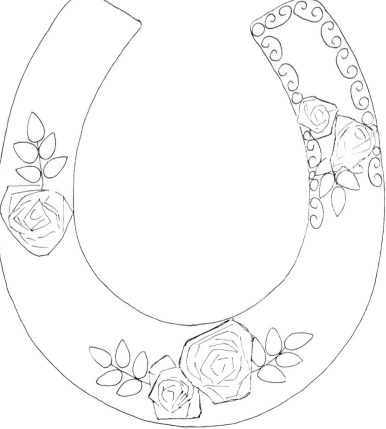

THE QUILLED DESIGN Use a long-headed beginner's tool with a collar to make the ribbon roses. Roll the paper around a couple of times to secure it, then fold the paper down at right angles and continue rolling carefully until the paper straightens out again. Turn down again and continue until the paper straightens out – repeat this process until you come to the end of the paper. Then, turn the end down and carefully

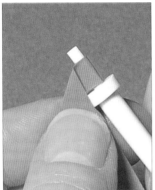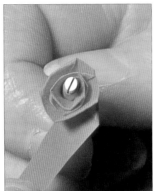

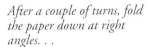

After a couple of turns, fold the paper down at right angles. . .

. . . and continue turning and folding to build up the shape.

remove the rose with your forefinger on the rose centre and your thumb supporting the bottom. Let it uncoil a little, but be careful or it will come completely undone! Apply glue to the bottom of the rose, making sure that the centre also catches the glue, and then press down the end of the paper over the bottom of the rose and hold in position until dry. I suggest that you practise on a spare piece of paper to get the technique right before making the actual roses for the horseshoe.

Make up the sets of leaves and stems using the technique explained on page 22, sticking the platform to one teardrop and then sticking the other teardrops on either side of the stem. Leave to dry.

You will need to use all-purpose or tacky glue to stick the pieces on to the horseshoe. Position the ribbon roses on the horseshoe shape and glue into place. Shorten the stems of the rose leaves as required and glue them into place.

Finally, glue the C-shapes around the edges (straight sides to the middle). If you have spaces that will not take a full C-shape, make loose coils from about one-sixteenth of a strip of paper and use these instead.

Flowers in a shoe – a special wedding memento

You can make this as a picture and add the bride's and groom's names and date of the wedding, or you could make it into a very special card. The choice is yours.

Materials

Piece of card

3mm ($\frac{1}{8}$in) quilling paper

Coloured inks, paints, or felt-tipped pens

Shapes

This design includes three different types of flower, each of which needs to be made up before being attached to the card.

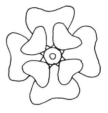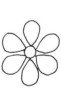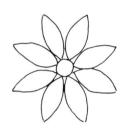

Flower 1.

Flower 2.

Flower 3.

FLOWER 1 (make three of these flowers)

BOTTOM LAYER – four one-third-strip heart shapes

TOP LAYER – four one-eighth-strip heart shapes

CENTRE – one one-quarter-strip bell shape

This shape is based on the principle of a peg, but after two or three turns of the tool let the paper go off-centre and keep rolling. Glue closed as for a peg and then carefully remove the conical shape from the tool. Glue the inside of the cone to stop it collapsing.

To make this flower, glue the four bottom petals around the base of the bell shape and then stick the four small petals on the top of them.

FLOWER 2 (make three of these flowers)

CENTRE – one one-eighth-strip peg

PETALS – six one-eighth-strip teardrop shapes

To make this flower, glue the petals around the peg.

FLOWER 3 (complete)

PETALS – eight one-quarter-strip eye shapes

CENTRE – one one-quarter-strip bell shape

FLOWER 3 (half)

PETALS – four one-quarter-strip eye shapes
– two one-eighth-strip eye shapes

CENTRE – one one-quarter-strip bell shape

To make up the complete flower, glue eight petals around the bell shape. The half flower is made from four petals glued to the bell shape with the two smaller petals at each side.

LEAVES

MODIFIED LEAF SHAPES – fourteen one-eighth-strip closed coils made into semi-circle shapes (seven in light green and seven in dark green)

Glue the light-green semi-circles to the dark-green ones along the straight edges and when dry modify each piece into a leaf shape.

SHOE

S-SHAPES – about forty one-eighth-strip S-shapes

Making up the design

First, make a tracing of the shoe outline and transfer it to your card. The inner heel can be painted in with ink, paint, or felt-tipped pen, using a colour similar to that of the shoe. In this example, I used a silver marker pen to complement the silver-edged white quilling paper used for the S-shapes. The bow on the back of the shoe is made from two loops of paper with two short strips for the 'tails'.

Arrange the made-up flowers on the shoe as shown on the pattern. Remember to let some flowers overlap others to give dimension to the finished piece.

Finally, fill the outline with the S-shapes. If you want to give the shoe a definite outline glue a strip of paper around the outer contour of the shoe, gluing it to the outer edges of the S-shapes.

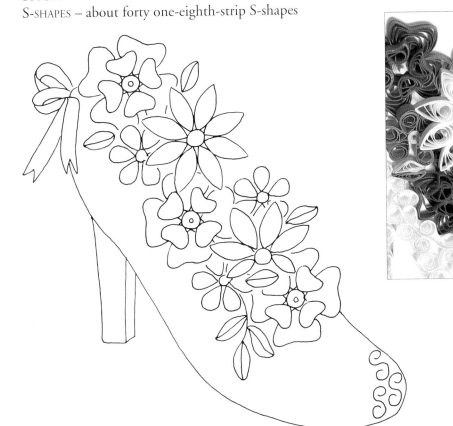

Projects for festivals

It is nice to send family and friends hand-made cards at Christmas and Easter, but you can also make three-dimensional decorations for your Christmas tree. In this section, I have included two tree decorations for you to try, as well as a design for an Easter card.

A Christmas tree

Materials

3, 5, or 7mm ($^1/_8$, $^3/_{16}$, or $^9/_{32}$in) quilling paper

Length of thread for a hanger

7cm ($2^3/_4$in) length of square balsa wood, obtainable from any good model shop

The width of paper that you use will determine the width of the balsa wood, so if you choose to use 5mm ($^3/_{16}$in) paper then you will need 5mm ($^3/_{16}$in) square balsa wood.

Shapes

Referring to the pattern, make up four sets of closed coils using the various lengths of paper as indicated, and then modify each one to the shape shown on the pattern (the bottom section is the tree tub).

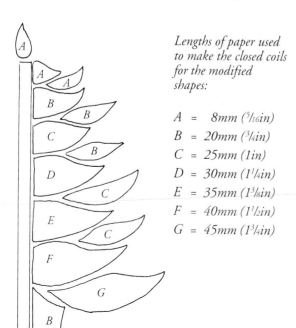

Lengths of paper used to make the closed coils for the modified shapes:

A = 8mm ($^5/_{16}$in)
B = 20mm ($^3/_4$in)
C = 25mm (1in)
D = 30mm ($1^1/_4$in)
E = 35mm ($1^3/_8$in)
F = 40mm ($1^1/_2$in)
G = 45mm ($1^3/_4$in)

Making up the design

Trace the pattern for the branches and tub on to baking parchment as a guide for assembling the tree. Start at the bottom and build up a section of the tree by gluing the leaf pieces together, making sure that you have a good straight edge down the left-hand side. Make up four sections.

Next, glue two quilled sections to the balsa-wood trunk, one on either side, then glue the third section to the top edge of the trunk (you may have to hold it in place until the glue dries if it starts slipping). Wait until these sections are really dry and then glue on the fourth section – again you must hold it in place until the glue has dried. Finally, glue the teardrop finial to the top of the trunk. Now, if you want to, you can decorate the tree with sequins and glitter.

When everything is dry, pass a thread through the top of the teardrop shape to make a hanger.

Candle in a ring

Materials

3mm ($^1/_8$in) quilling paper

Two lengths of silver thread

Circular object, such as a jar lid

Shapes

You will need to quill the following:

RING – thirty-six one-eighth-strip closed coils (half in red and half in green)

CANDLE – four one-eighth-strip closed coils (in white)

CANDLE FLAME – one petal shape made from a one-sixteenth-strip of orange paper glued to a one-eighth-strip of yellow paper

HOLLY – six one-eighth-strip star shapes (in green)

BERRIES – seven one-eighth-strip pegs (in red)

HANGERS – one one-eighth-strip open peg wound around the handle of the quilling tool (outer)
 – one one-eighth-strip peg (inner)

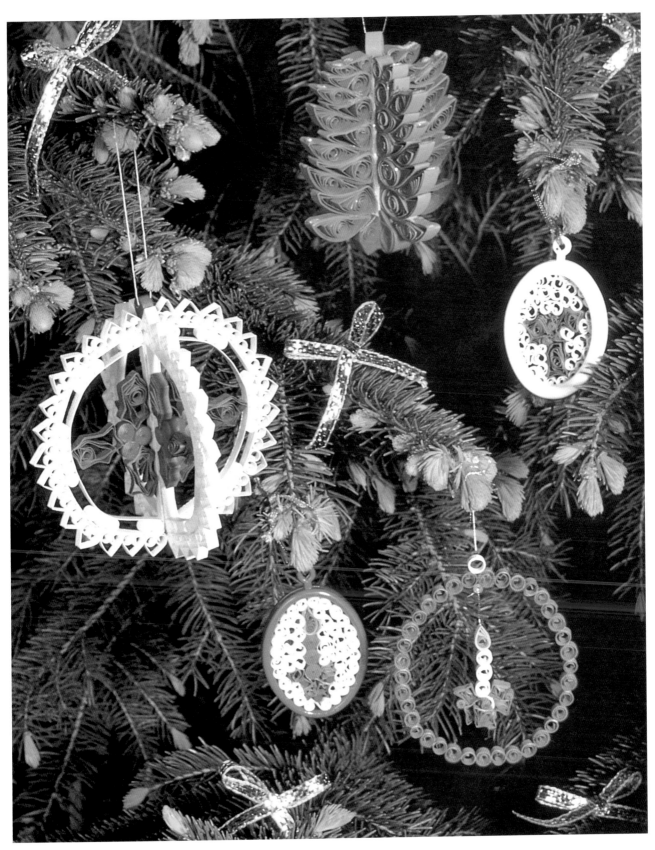

A selection of decorations for the Christmas tree.

Making up the design

Fasten a clean piece of baking parchment to your quilling board and draw around a circular object, e.g. a jar lid. My circle was 7cm (2¾in) in diameter.

Glue the closed coils together, using the circle on the baking parchment as a guide and pins to keep them in position. Alternate the colours. Stick the top hanger to the outside of the circle and the peg hanger directly underneath. Then glue the four white coils together, using a straight line as a guide, and attach the flame.

Glue two holly leaves and a berry to each side of the candle (between the third and fourth coils) and three berries in a pyramid shape to the bottom of the candle. Glue a holly leaf and berry over the bottom coil of the candle and repeat this on the other side.

Attach the candle to the inner top hanger by passing a silver thread through the centre of the peg and the top of the candle flame. Tie a knot in the thread when the candle is hanging in the middle of the circle. Pass another piece of silver thread through the top hanger and make a loop to hang on the tree.

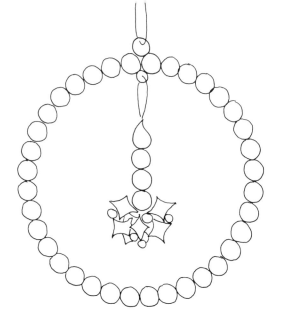

Do try experimenting. Here, I have used quilling to decorate a candle and a paper bauble.

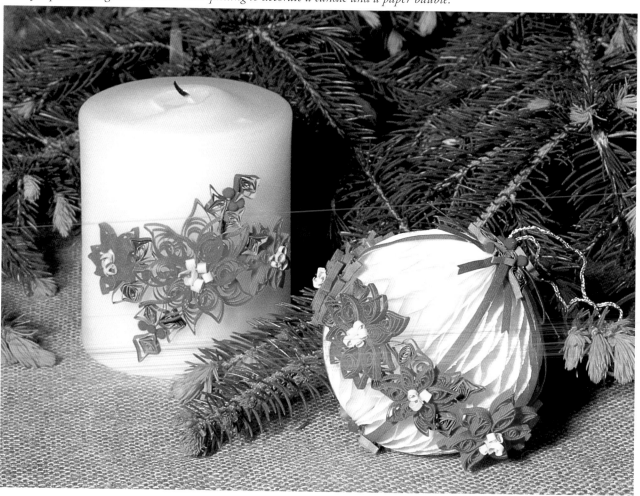

40

Easter card

Materials

Three-fold oval greetings card with an aperture

3mm ($^1/_8$in) quilling paper

Dark-green paper

Shapes

FILIGREE CROSS – follow the instructions given for the First Communion or condolence card on page 32 to make the filigree cross, omitting the closed coil on top of the central cross. I used yellow pearl-edged paper for my cross.

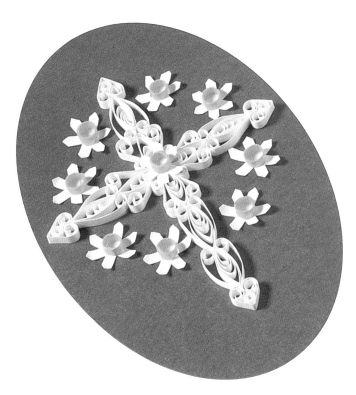

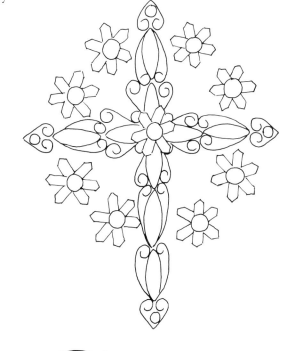

Enlarged view of miniature daffodils.

Making up the design

First, stick the dark-green paper inside the aperture of the card to give a background to the design. Next, glue the filigree cross into place on the card.

Finally, glue one daffodil to the centre of the cross and position the others as shown.

This is a good example of the way in which you can adapt a quilling pattern to suit any occasion.

DAFFODILS – make nine miniature daffodils. Cut three 2cm ($^3/_4$in) long strips of 3mm ($^1/_8$in) white paper and glue them together as shown. With a pair of quilling scissors, cut the ends of the paper strips to points and gently curl the paper upwards.

Using a 3cm ($1^1/_4$in) strip of orange paper, wrap this around the handle of the quilling tool and glue it closed as an open peg. Glue this to the centre of the crossed strips of white paper.

Advanced projects

Parasol with flowers

Here is a card for any occasion – you can use the parasol by itself or add flowers to your own taste.

Most of the parasol is made from *huskings*. This is an eighteenth-century technique in which the paper is wound around pins to give the shape required. By altering the position of the pins you can make different sizes and shapes of huskings. In the eighteenth century ladies used these to produce even shapes to decorate the borders of boxes and pictures.

Materials

Blank greetings card

3mm (1/$_8$in) quilling paper

1.5mm (1/$_{16}$in) quilling paper

Shapes

You will need to quill the following:

FLOWERS You can make any flowers you like, but if you want to make them the same as mine, then choose 3mm (1/$_8$in) paper in a colour similar to your background and make:

 – thirty-five one-eighth-strip teardrops

 – seven one-eighth-strip pegs

LEAVES – six one-eighth-strip leaf shapes

PARASOL – five four-pin huskings (see opposite)

 – three one-third-strip pegs, one made from 3mm (1/$_8$in) and two from 1.5mm (1/$_{16}$in) paper (the same colour as the huskings)

 – ten one-eighth-strip C-shapes

 – five one-eighth-strip S-shapes

 – one one-quarter-strip triangle

 – one one-quarter-strip closed coil

 – 45mm (1^3/$_4$in) strip for the handle

 – 15mm (5/$_8$in) strip for the ferrule

 – short strips for the bow

Making up the design

First, make up all the individual huskings and flowers on the board and put them to one side.

Now, apply glue to the long side of each husking and stick them together – I used two pins to keep the

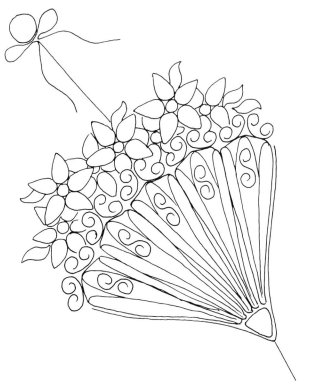

bottom edge of the huskings close together. Glue the triangle to the bottom of the huskings. Now, to hold the parasol together, glue a strip of gilded paper from the top of one long edge, around the triangle and up to the top of the other side.

Next glue the S-shapes into the huskings and the C-shapes to the top edge of the parasol, positioning them as shown in the diagram.

Lay the parasol, together with the handle, its closed-coil end, and the ferrule on the card and adjust them until you get the best angle.

Glue the 3mm (1/$_8$in) peg under the parasol, beneath the join of the middle two C-shapes, and the two 1.5mm (1/$_{16}$in) pegs similarly, half-way between each side and the middle peg. These will raise your parasol from the card in a realistic manner.

Now apply glue to the three pegs, to the two long outer edges of the huskings and also to the triangle, and stick them to your card. Glue the handle strip into place on its side and add the closed coil. Glue the ferrule on its side.

Make two loops from 3mm (1/$_8$in) paper and glue one on each side of handle under the knob – shape two more strips of paper for the ribbon ends and glue them into place under the loops.

Finally, arrange the flowers – I have four flowers stuck directly to the card and three flowers stuck on top of those. Glue the leaves into place.

How to make huskings

1. Copy the pin placings on to the baking parchment on your designer board (number them until you get used to making huskings).

2. Push a pin into each placing and then, starting at pin 1, wind the paper up around pin 2 and back to pin 1.

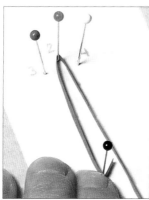

3. Now wind the paper around pin 3, back to pin 1, up around pin 4 and back down to pin 1 again.

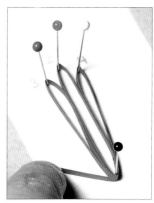

4. Finally, wind the paper right around the outside of the pins, tear off any excess paper and glue the end down. Carefully remove the pins from the board and lift the husking off. Re-insert the pins into the same holes to make the next one.

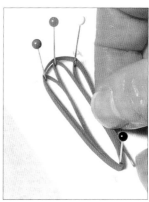

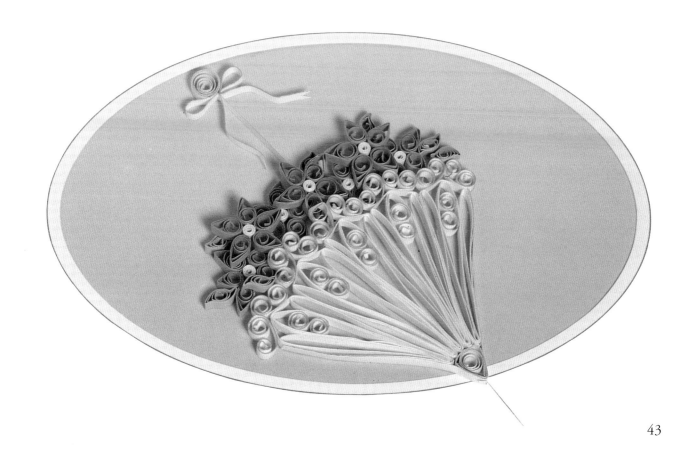

A bouquet of flowers

Materials

Blank greetings card

55mm (2¼in) posy frill or ruff, obtainable from quilling specialist suppliers

3mm (⅛in) quilling paper

7mm (⁹⁄₃₂in) quilling paper

10mm (³⁄₈in) quilling paper

Shapes

You will need to quill the following:

POSY RUFF – one 3mm (⅛in) two-thirds-strip loose coil
– one 7mm (⁹⁄₃₂in) one-quarter-strip peg
– strips of 3mm (⅛in) paper for double bow

You can fill the posy ruff with any flowers you like, but if you want to make them like mine then you will need the following:

FRINGED FLOWERS – four, each one made from a one-quarter-strip of 10mm (³⁄₈in) paper with a centre made from a one-eighth-strip of 3mm (⅛in) paper
– one made from a one-eighth-strip of 7mm (⁹⁄₃₂in) paper with a centre made from a one-sixteenth-strip of 3mm (⅛in) paper
– three, each made from a one-eighth-strip of 7mm (⁹⁄₃₂in) paper but with *no* centres

The following are all made from 3mm (⅛in) paper

PEG BUDS – seven one-eighth-strip pegs
– eight one-twelfth-strip pegs
– twelve one-sixteenth-strip pegs

LEAVES – four one-quarter-strip leaf shapes

TENDRILS – two one-eighth-strip V-shapes

STEMS – short strips glued on their sides

Making up the design

Make up three spire-like flowers. First, glue a stem to one of the smallest peg flowers using the method for assembling leaves (see page 22). Now, apply glue down the two sides of the stem and arrange a further two of the smallest pegs, two of the mid-sized pegs and two of the large ones down the length of the stem. The pegs you have left over can be made into oval buds, by pressing between your finger and thumb, and then glued to other stems.

Next, glue the loose coil into the shaped centre of the posy ruff. Put some glue into the ruff and then

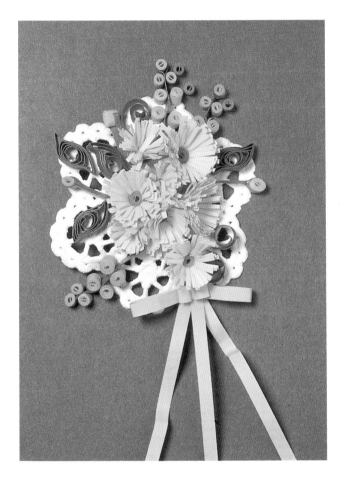

drop your coil into it and arrange it with your finger! This is to give you a better surface for the flowers.

Now glue the 7mm (⁹⁄₃₂in) wide peg on to the back of the posy ruff as a support. Glue the posy ruff to the card by applying glue to the peg and to the edge of the ruff opposite the peg. This will cant the posy ruff at an angle. Add a double bow and ribbon ends to the glued-down edge of the posy ruff.

Finally, arrange the flowers and foliage in the posy ruff as you wish and glue into place.

And finally...

I do hope that you have enjoyed this taste of quilling and that you now feel inspired to try your hand at creating your own designs.

Inspiration for quilling designs can come from all sorts of places, such as wallpaper, embroidery patterns, botanical paintings and books – trace them, keeping the shapes simple, and then experiment with spare pieces of quilling paper to obtain the look that you want. Do make notes of the lengths and widths of paper you use when making your own patterns and keep these in a notebook or a loose-leaf file so that you can find them again when you want to make a similar design. If you have made too many flowers or shapes for a project keep the extra ones in a box so that you can use them at a later date. If you want to make a card in a hurry you will be glad of your 'bits and pieces' box.

Once you have learnt the basic techniques and the shapes that you can use, the only boundaries are those of your imagination. You can make anything from tiny gift tags with a couple of airy flower buds on them to a whole box densely covered with solid quilling.

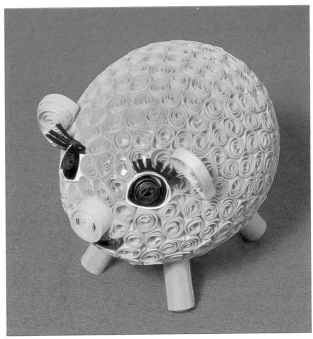

Quilling can be humerous too. This little pink pig started out life as a blown hen's egg.

Three-dimensional work can be particularly creative: try making miniature flowers in tiny quilled pots, or scrollwork earrings (varnished for durability), mobiles and lots more.

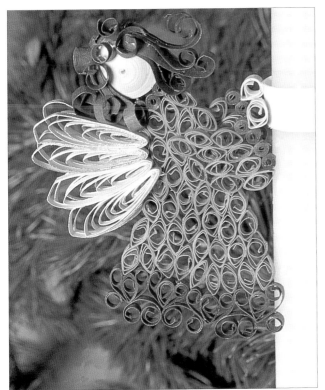

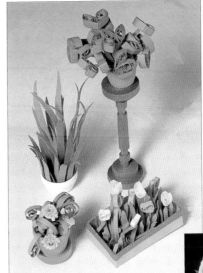

Some examples of miniature quilling. The planters (left) were made for a doll's house. The basket of flowers (below), at a slightly larger scale, was made to decorate a glass cabinet.

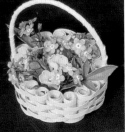

Left: Do let your imagination go to work! Here, I took an existing pattern for an angel and developed it into this candle decoration.

A great many people look at my work and say that they did not realize how intricate 'real' quilling is nor did they realize how beautiful the finished pieces can be. There are numerous excellent and innovative quillers in Great Britain and also in the Netherlands but, unfortunately, their beautiful work is very rarely seen in public. However, you too can become an expert – it may take a little time and patience, but then, you cannot create a work of art in a few minutes! Just remember that the more you do the better you will become.

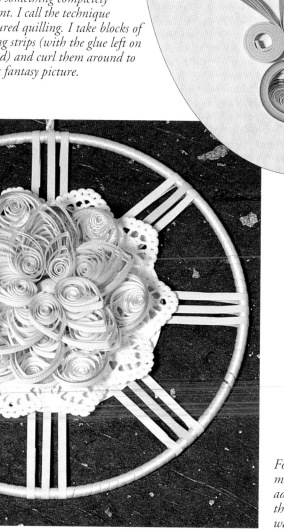

This is something completely different. I call the technique sculptured quilling. I take blocks of quilling strips (with the glue left on one end) and curl them around to form a fantasy picture.

For this window hanging I covered a macramé ring with ribbon, and then added strips of quilling paper to make the framework to support a quilled water-lily in a posy ruff.

46

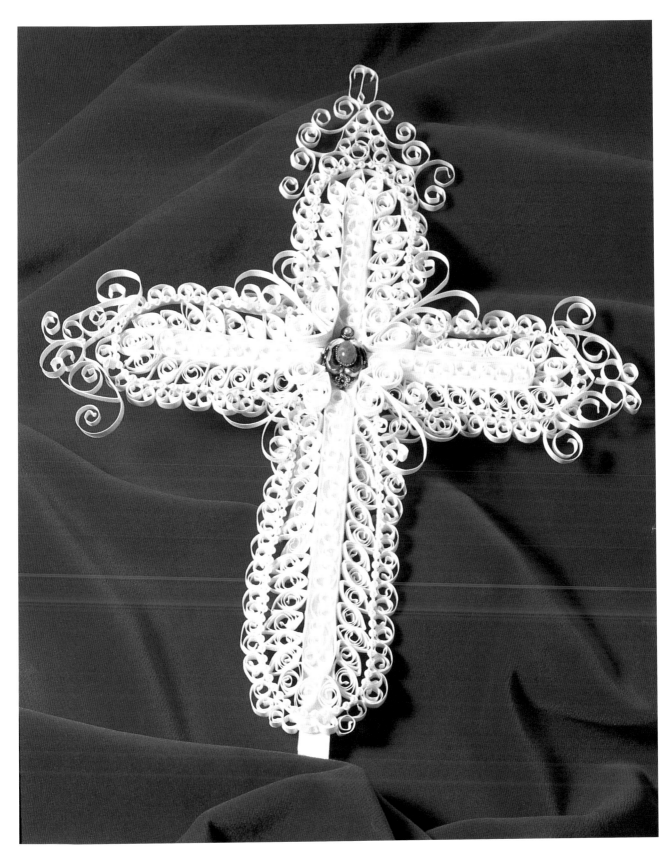

A quilled cross which is based upon an Italian gold-filigree cross.

Index

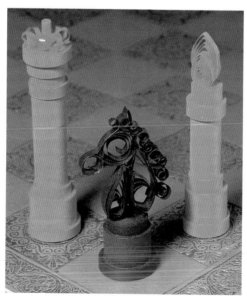

Chessmen. These consist primarily of pegs, rolled with different lengths of paper and stuck together to form columns. They are decorated with various quilling shapes to identify individual pieces.